WALKING THROUGH NATURE

GREYSCALE COLORING BOOK

By Agafa Criss

© 2018 Agafa Criss. All rights reserved.

This book belongs to:

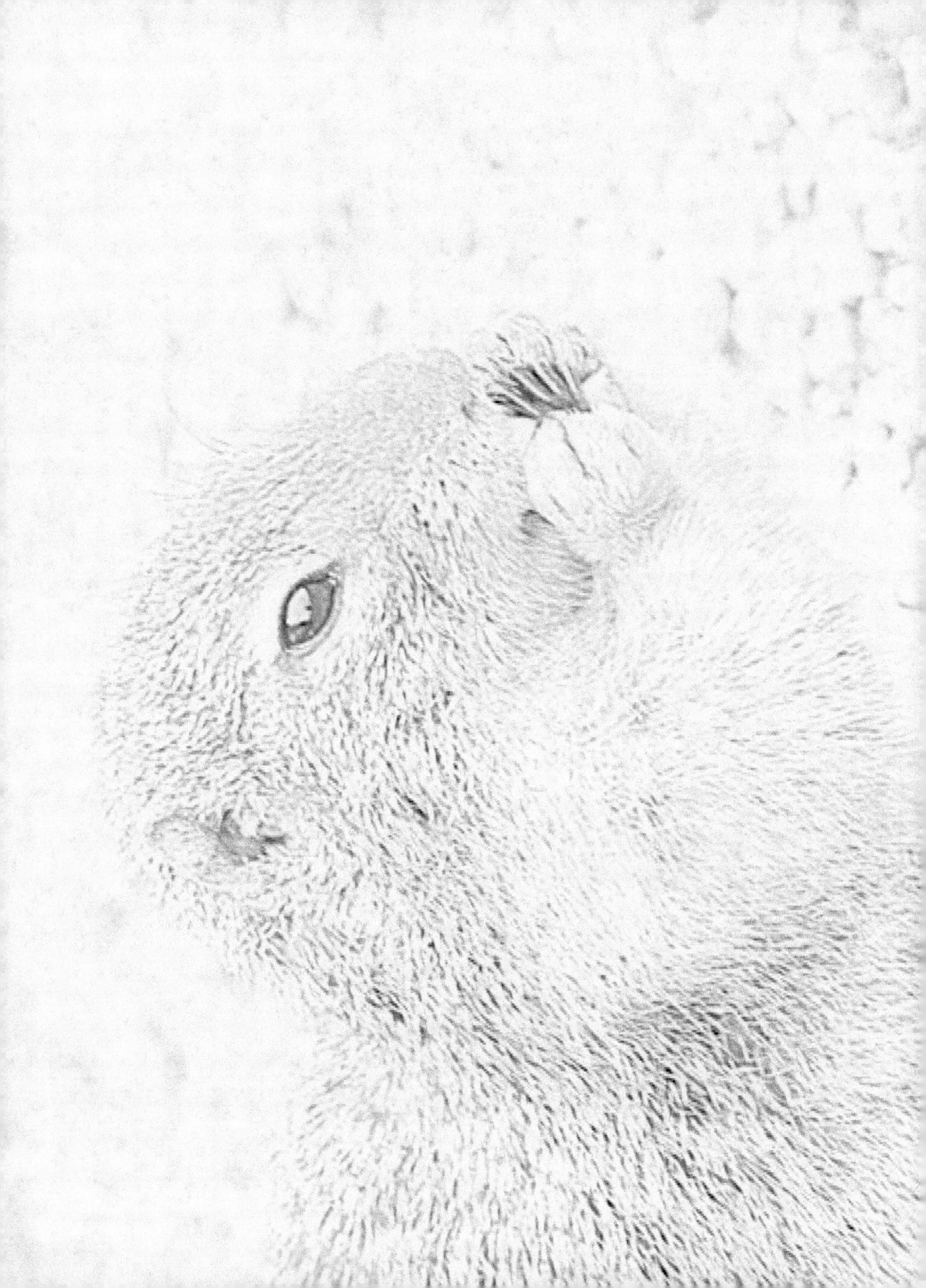

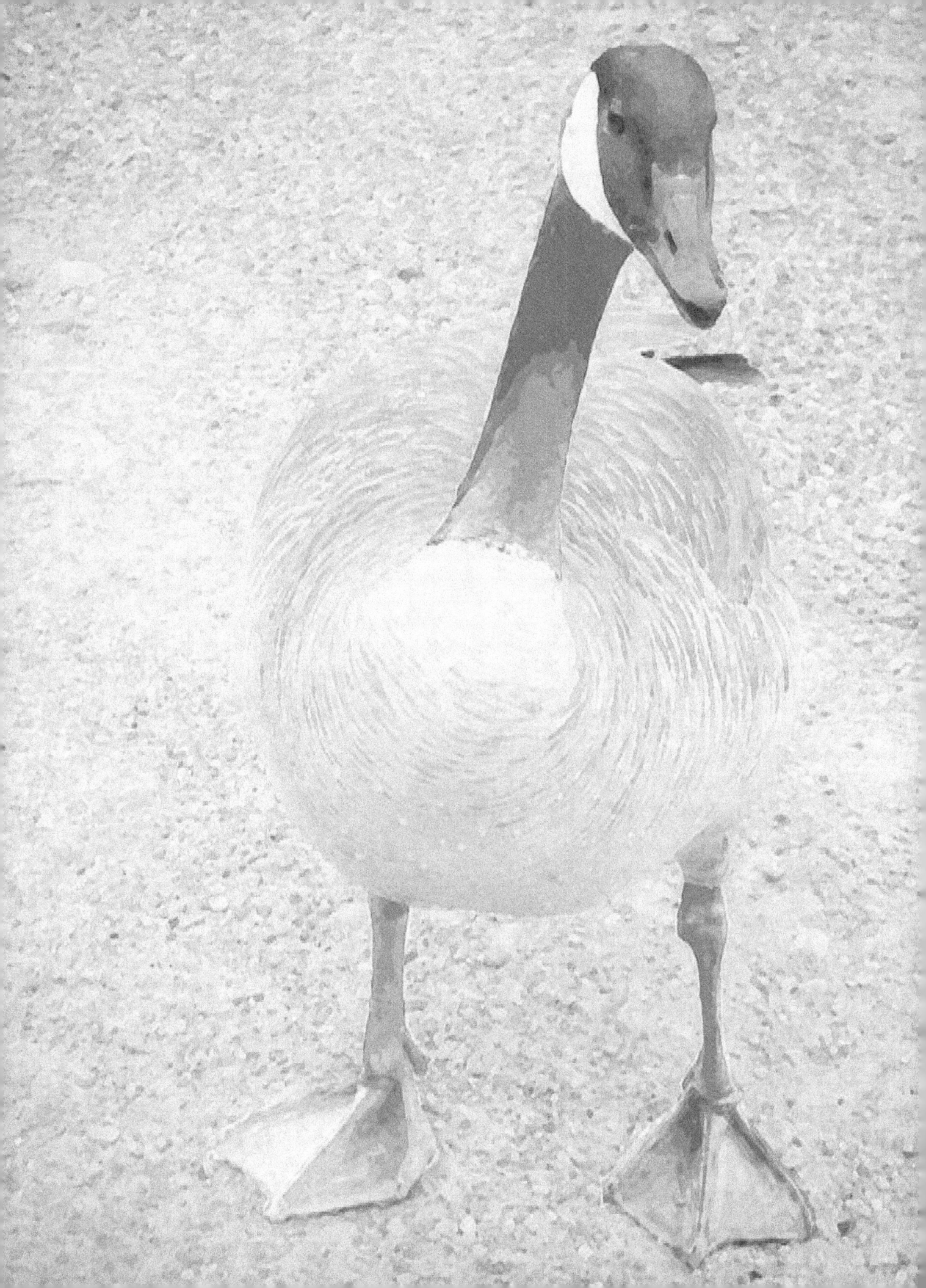

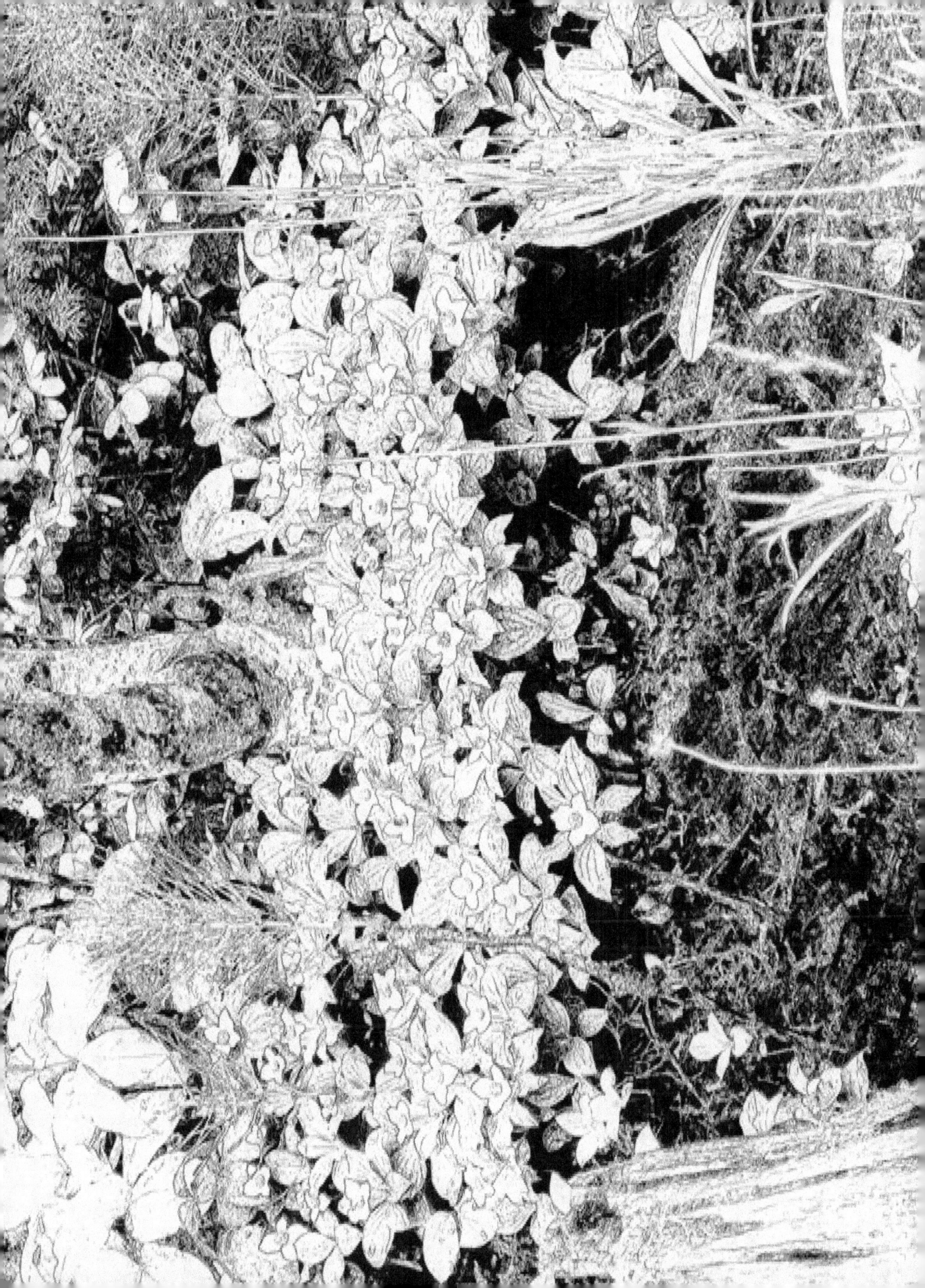

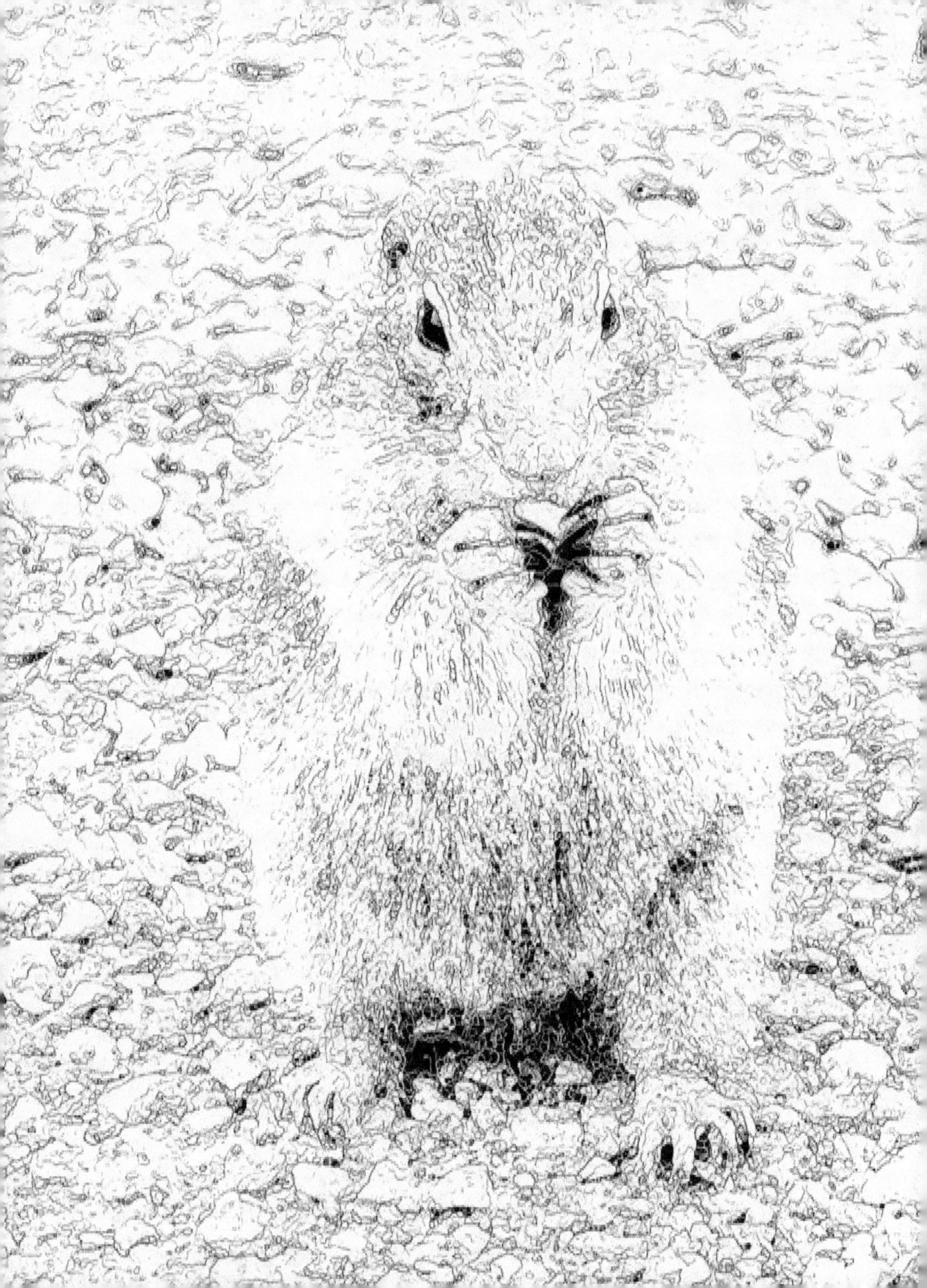

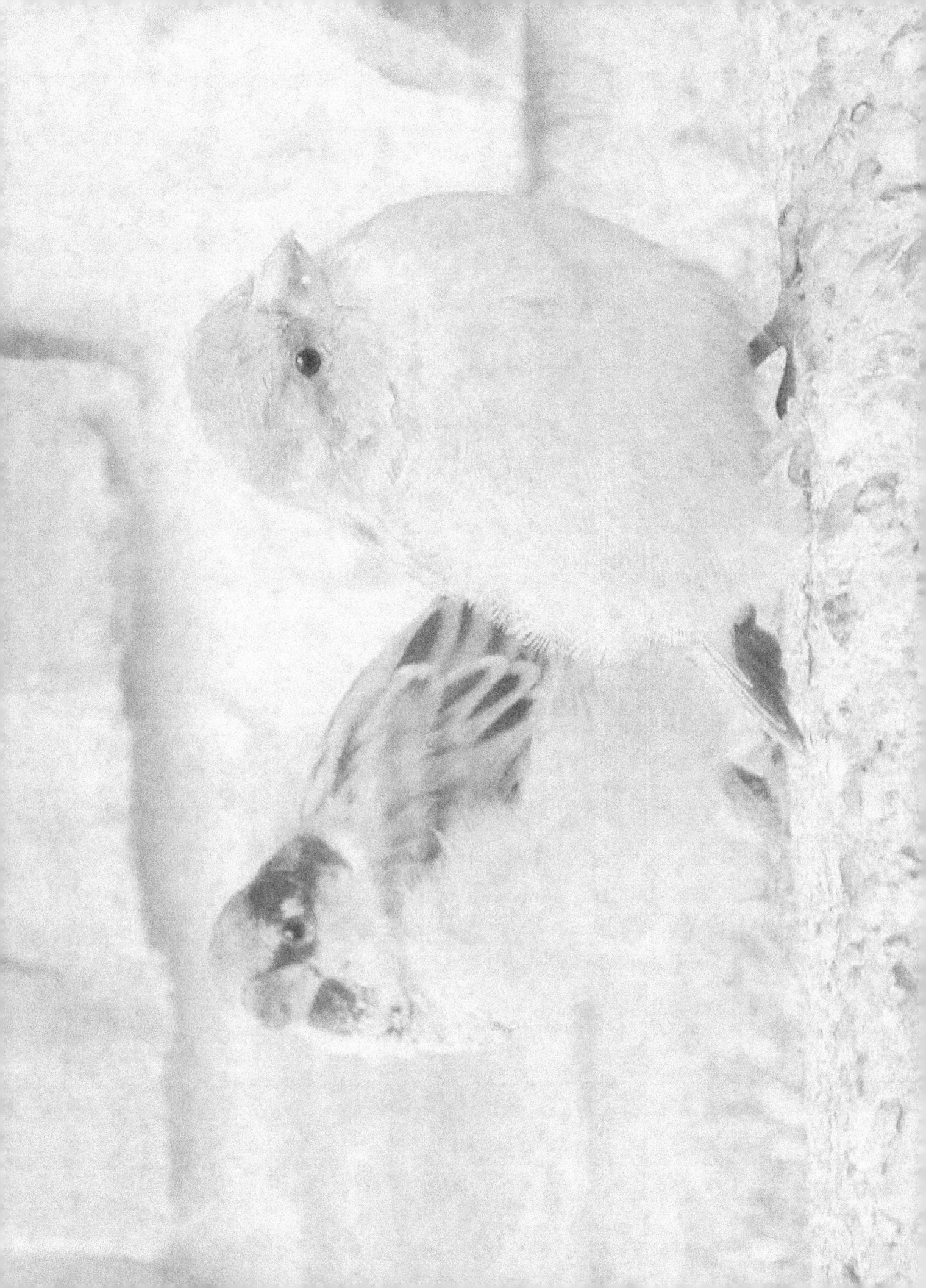

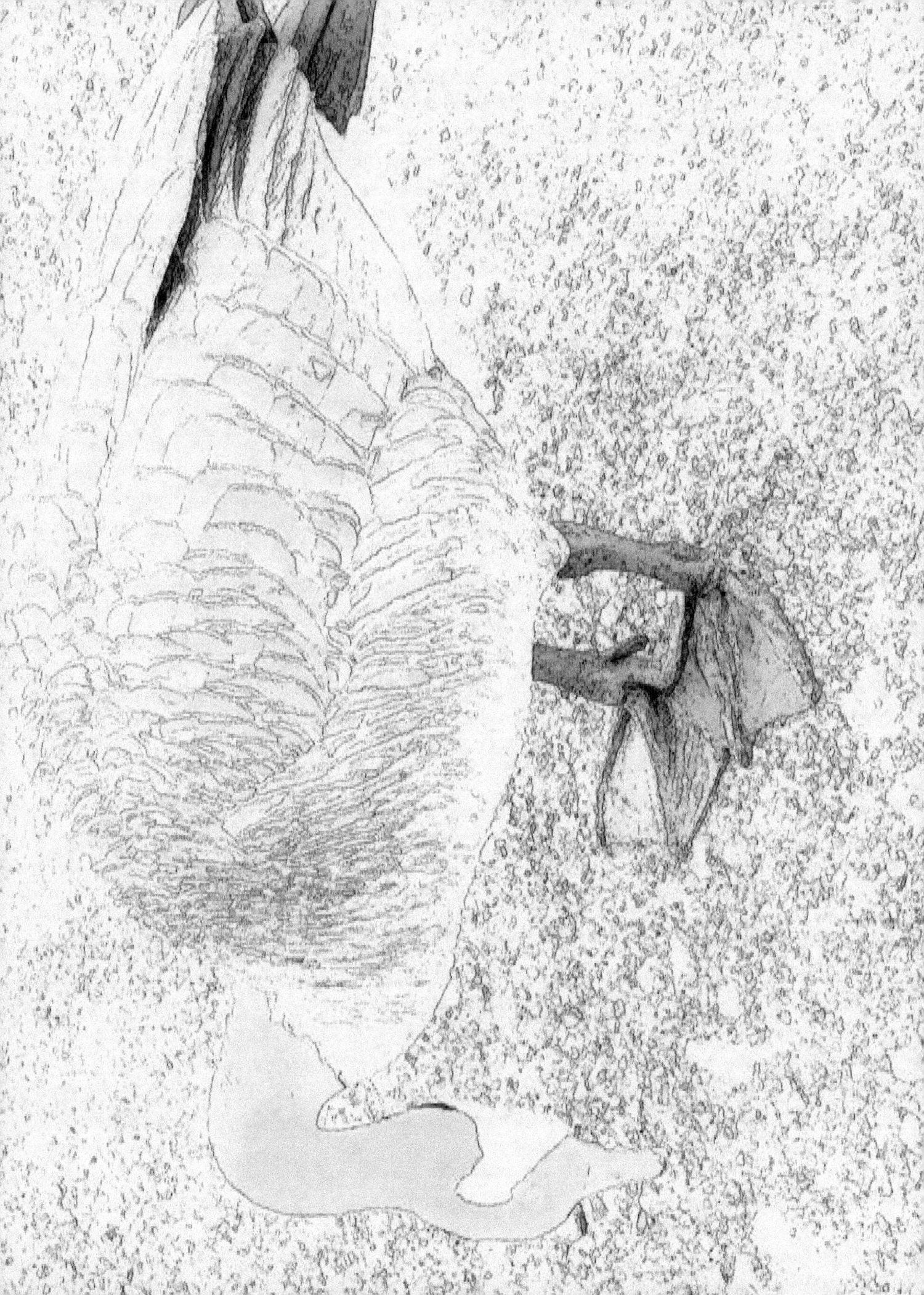

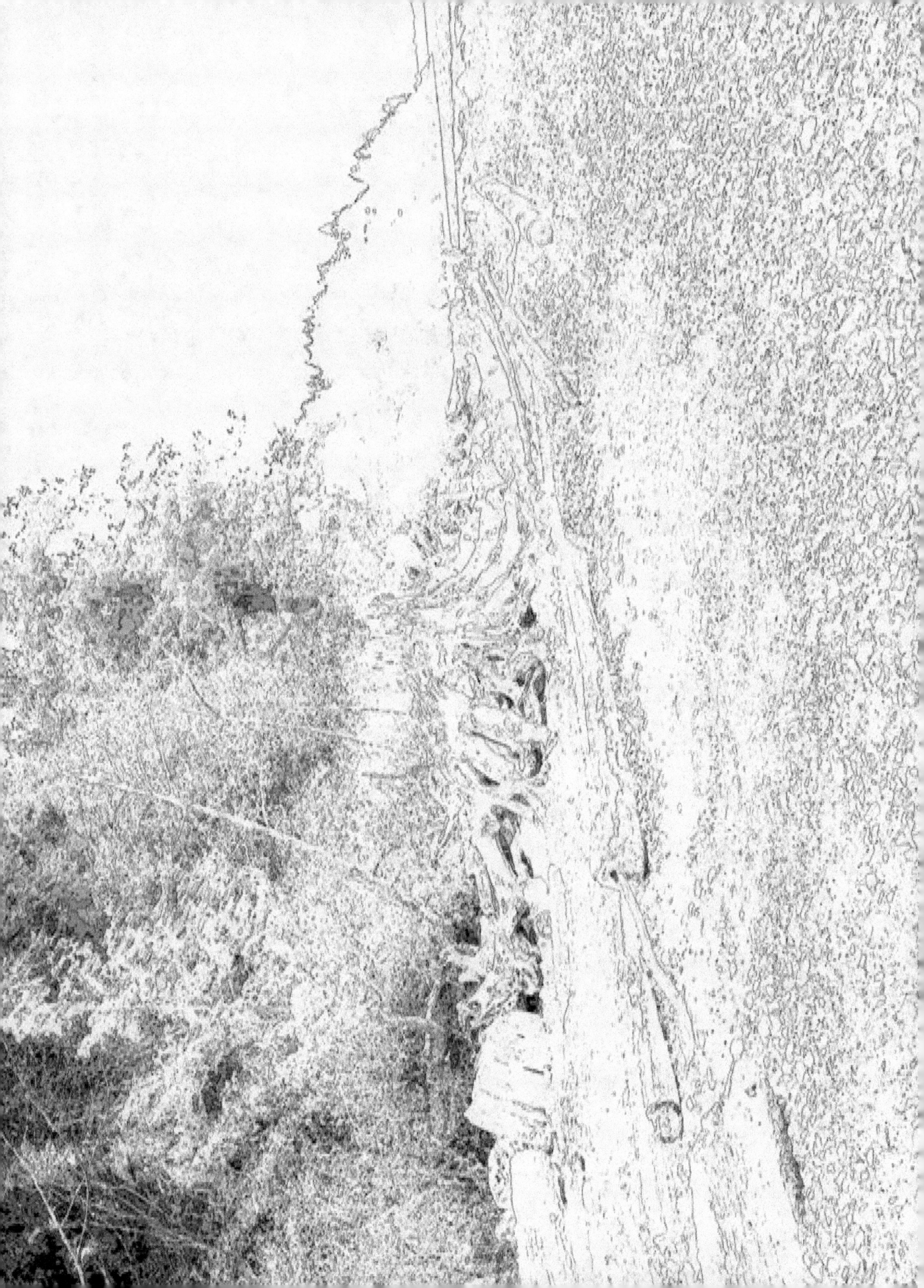

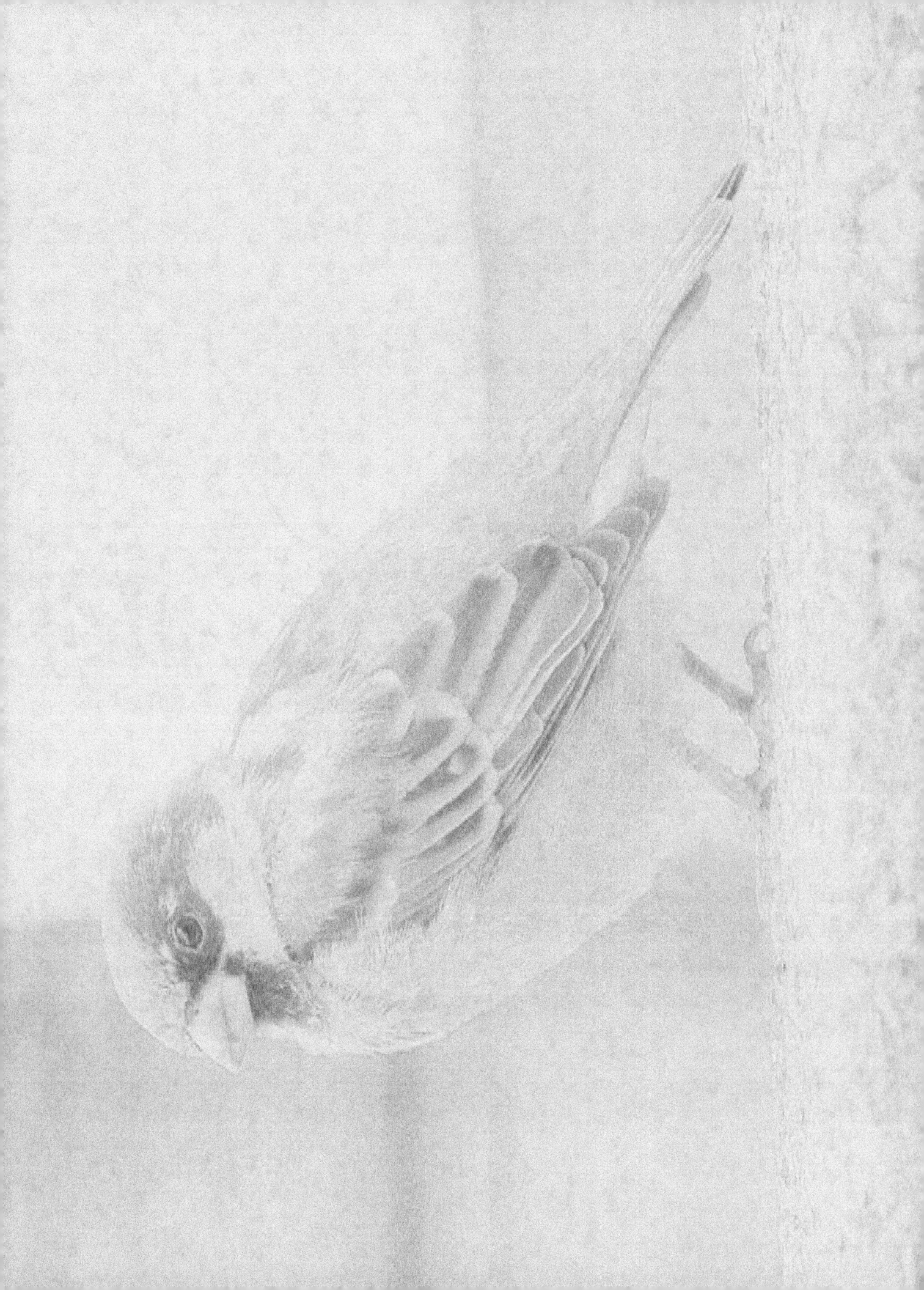

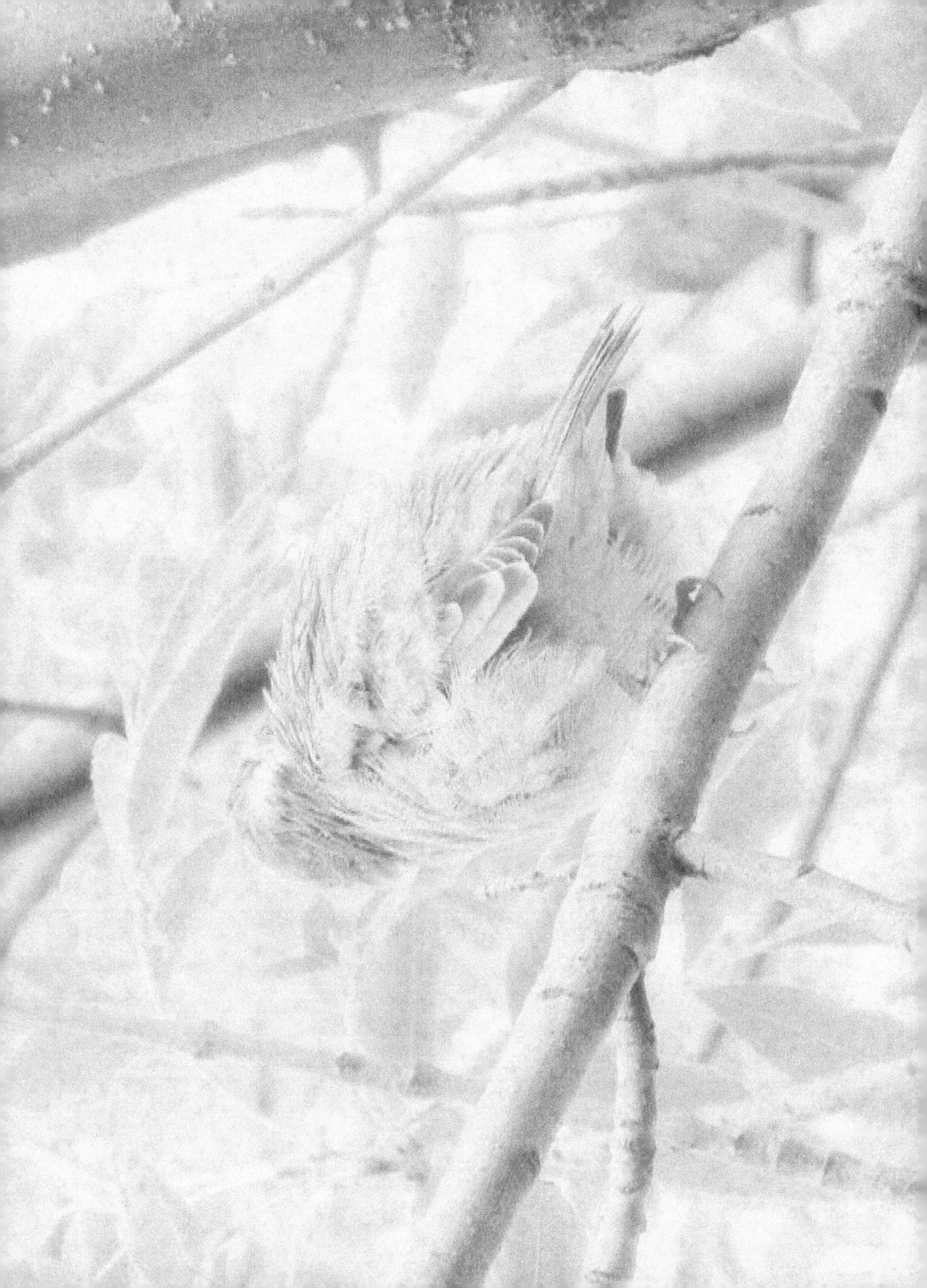

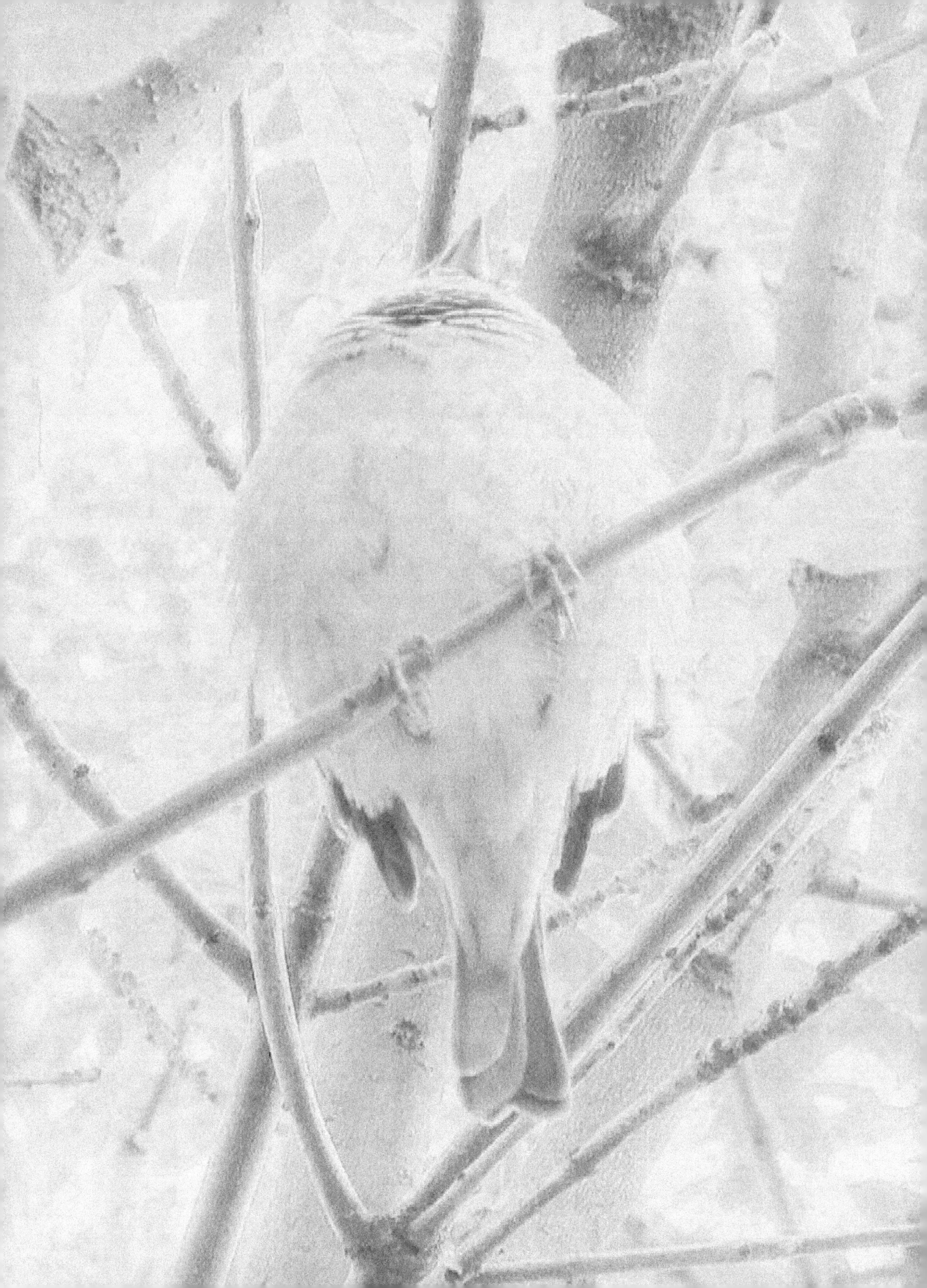

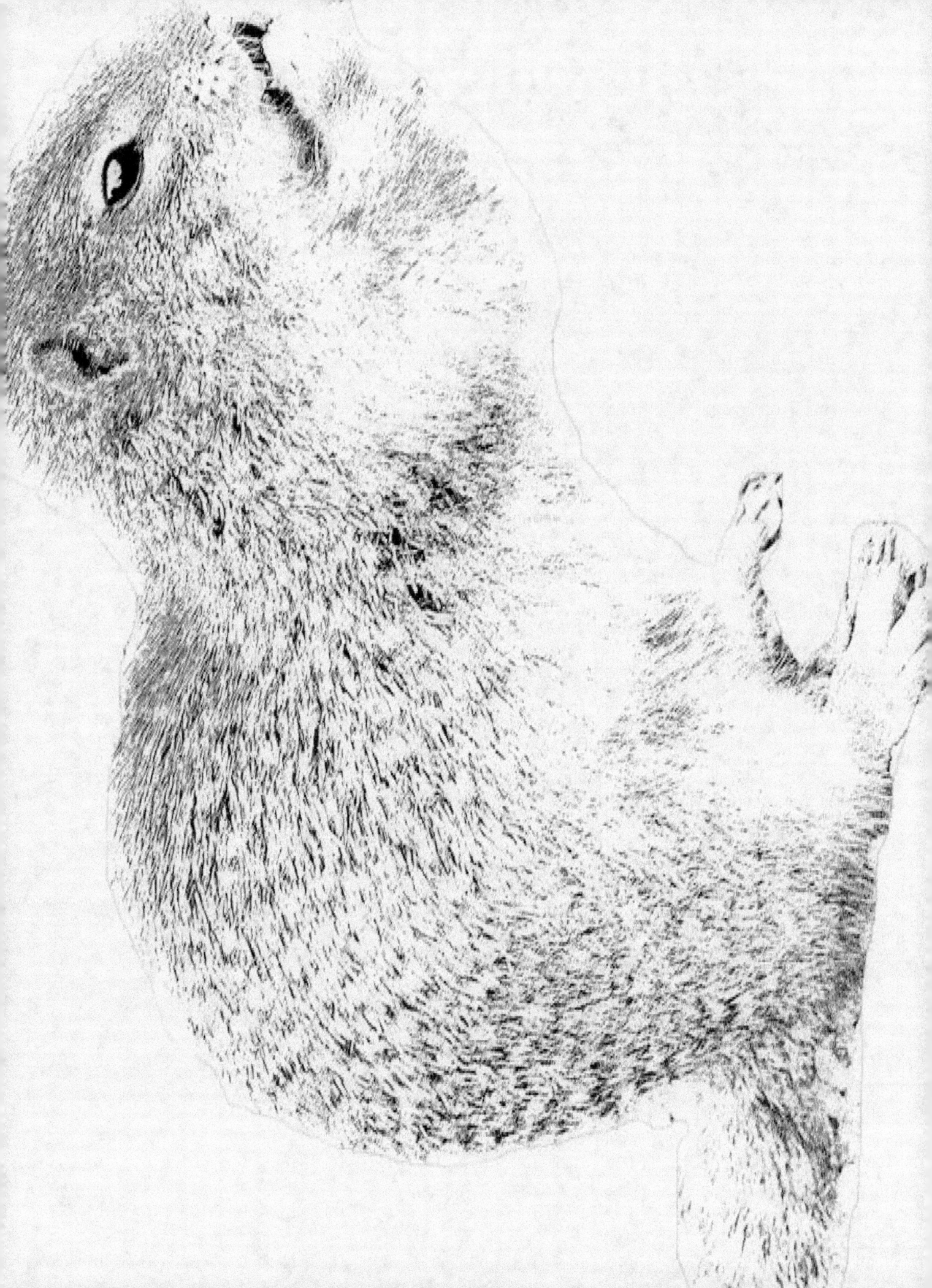

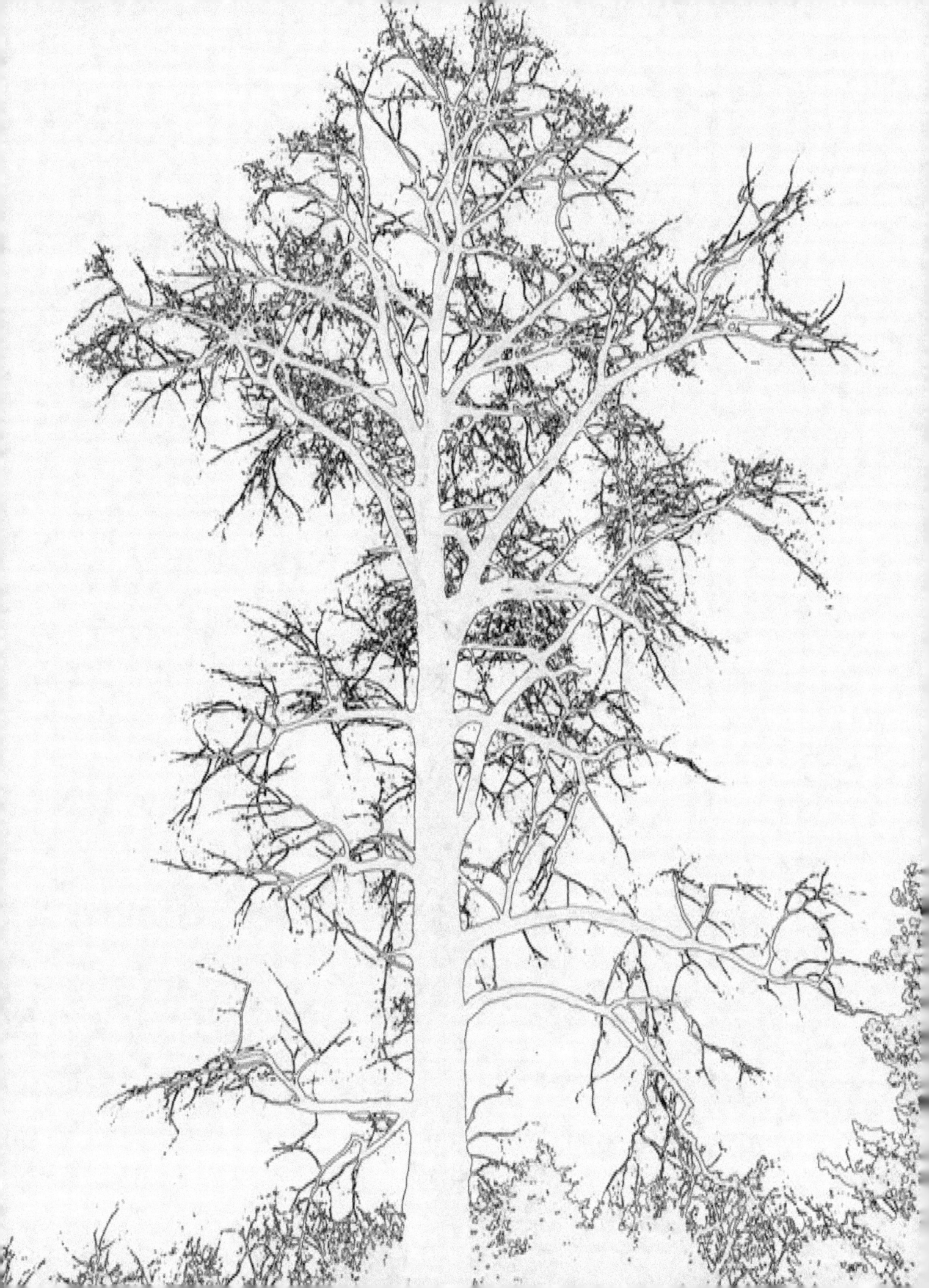

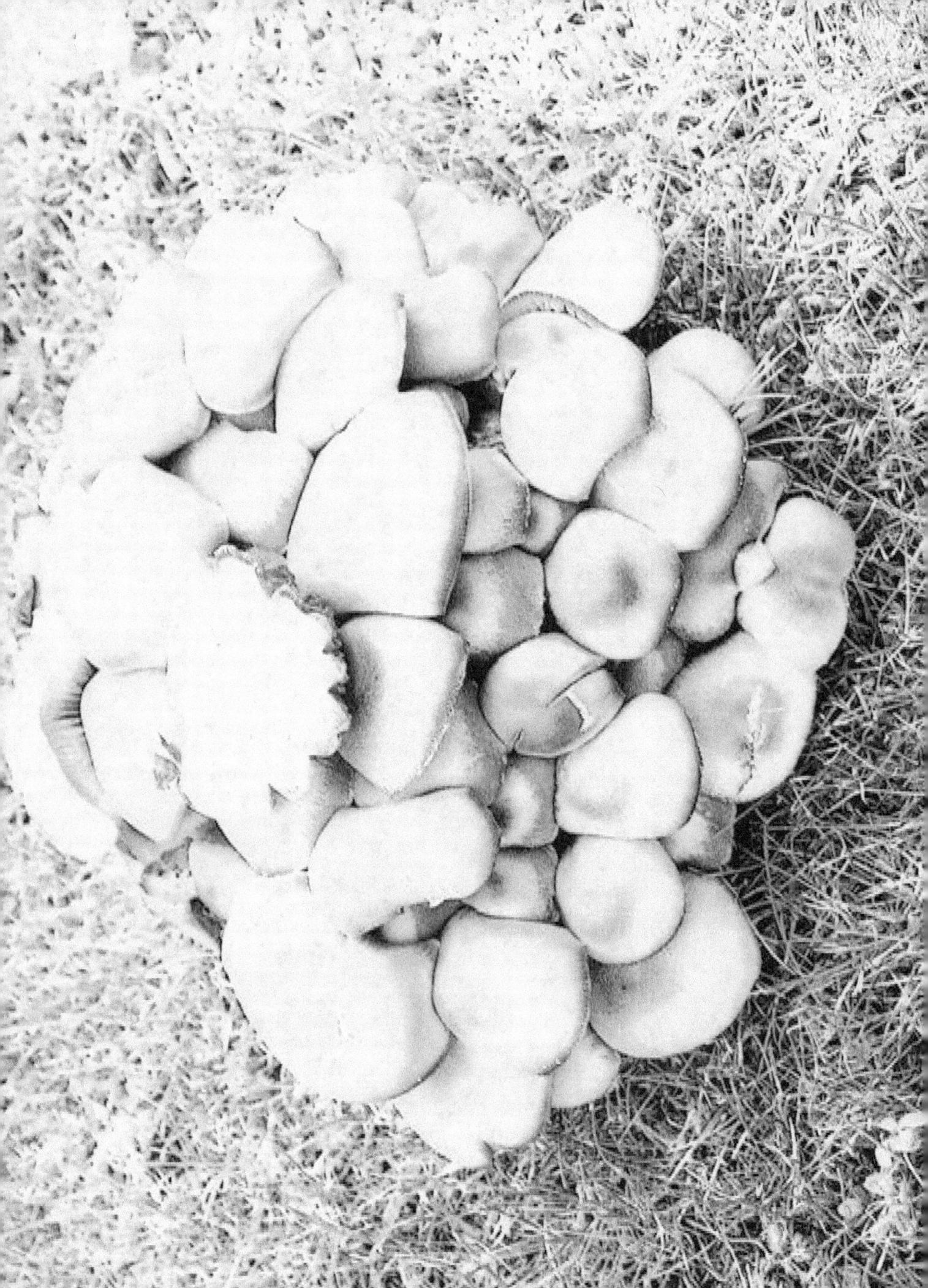

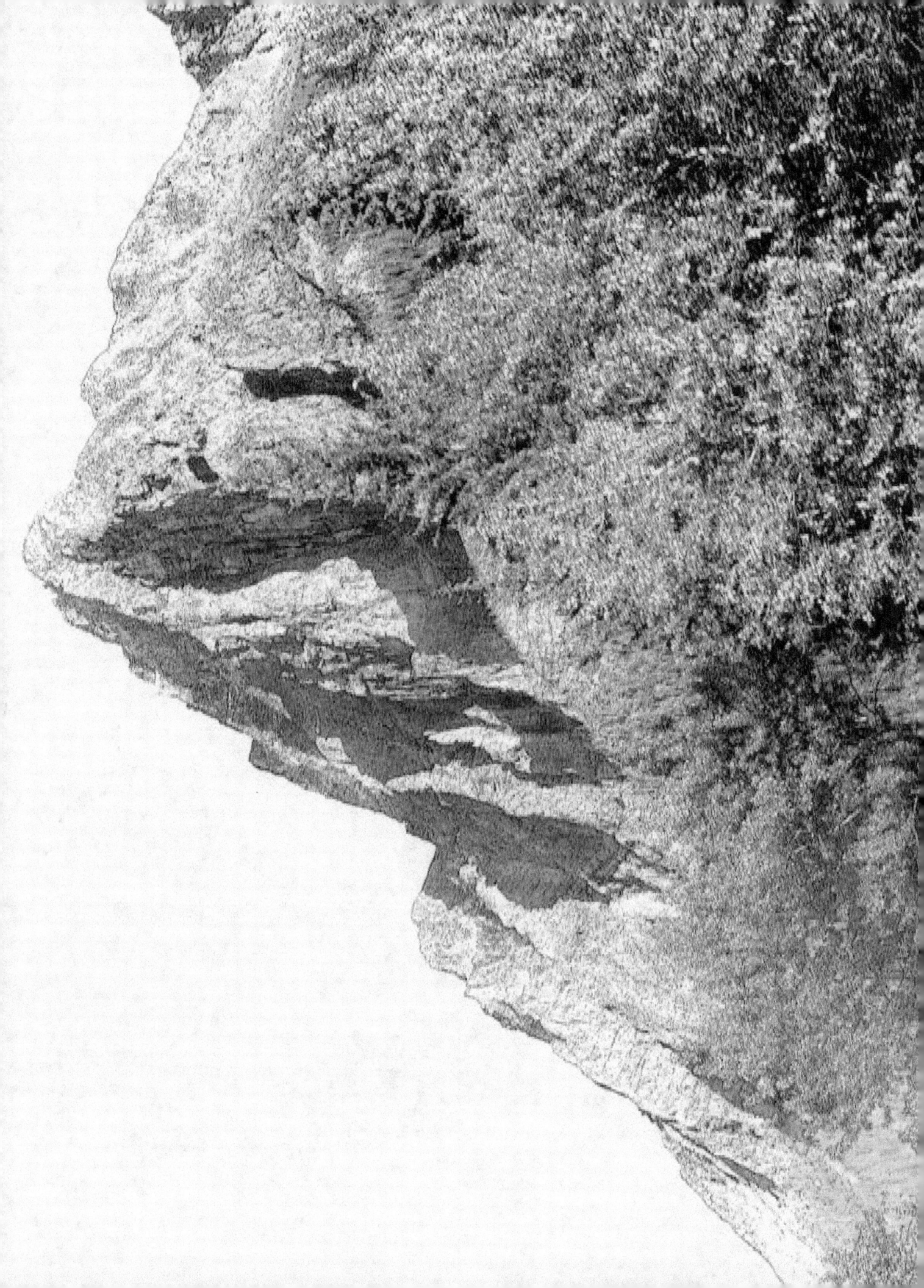

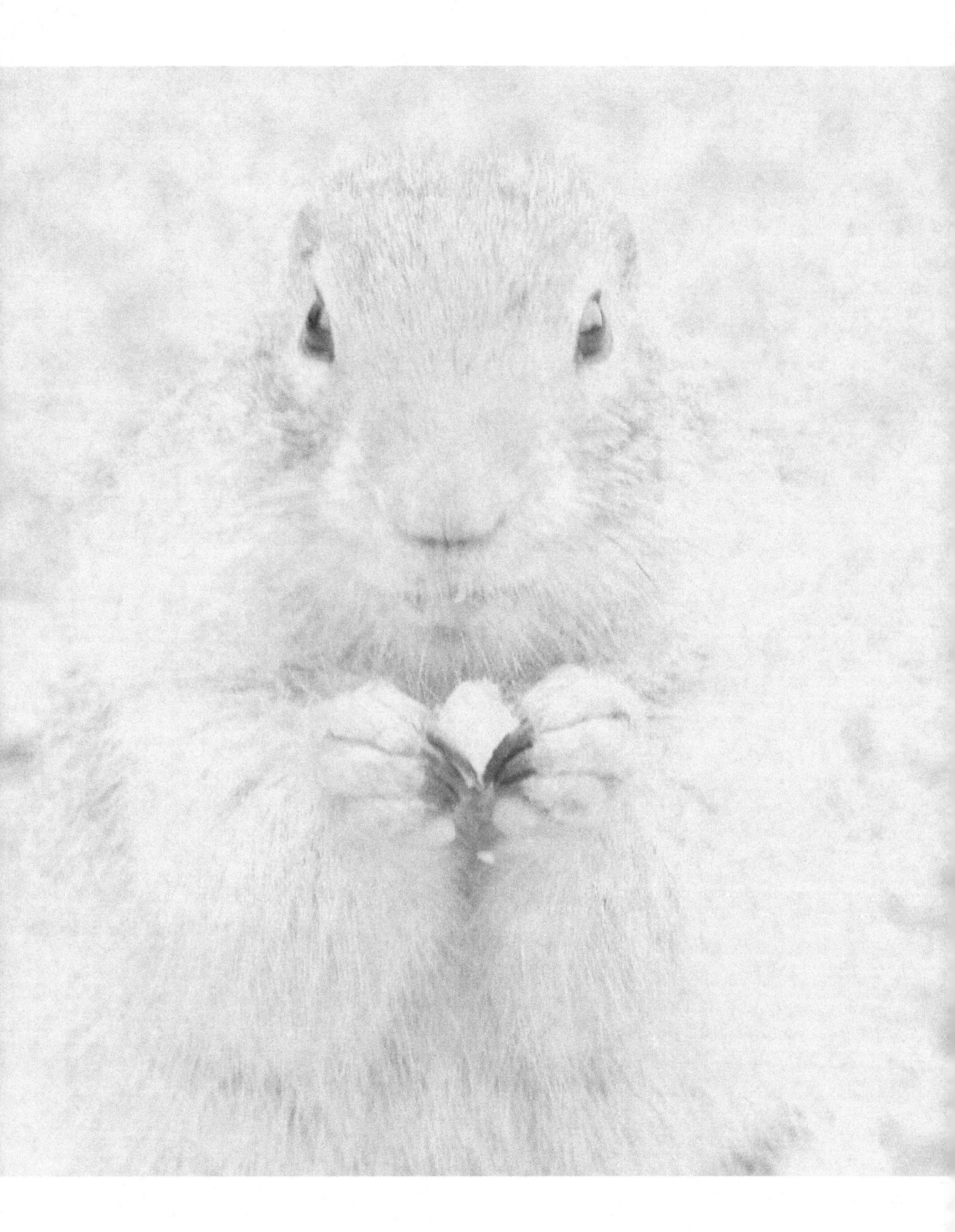

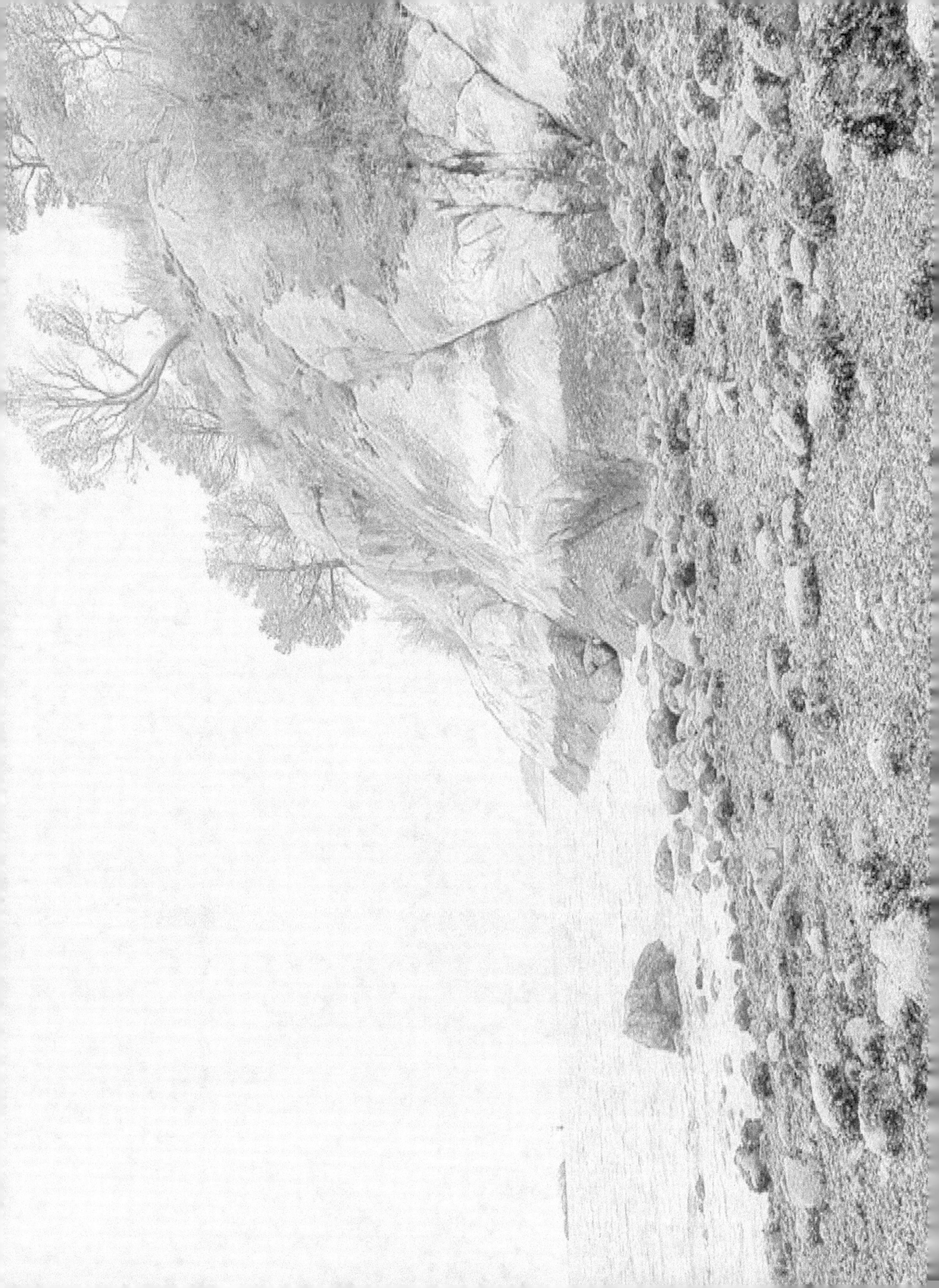

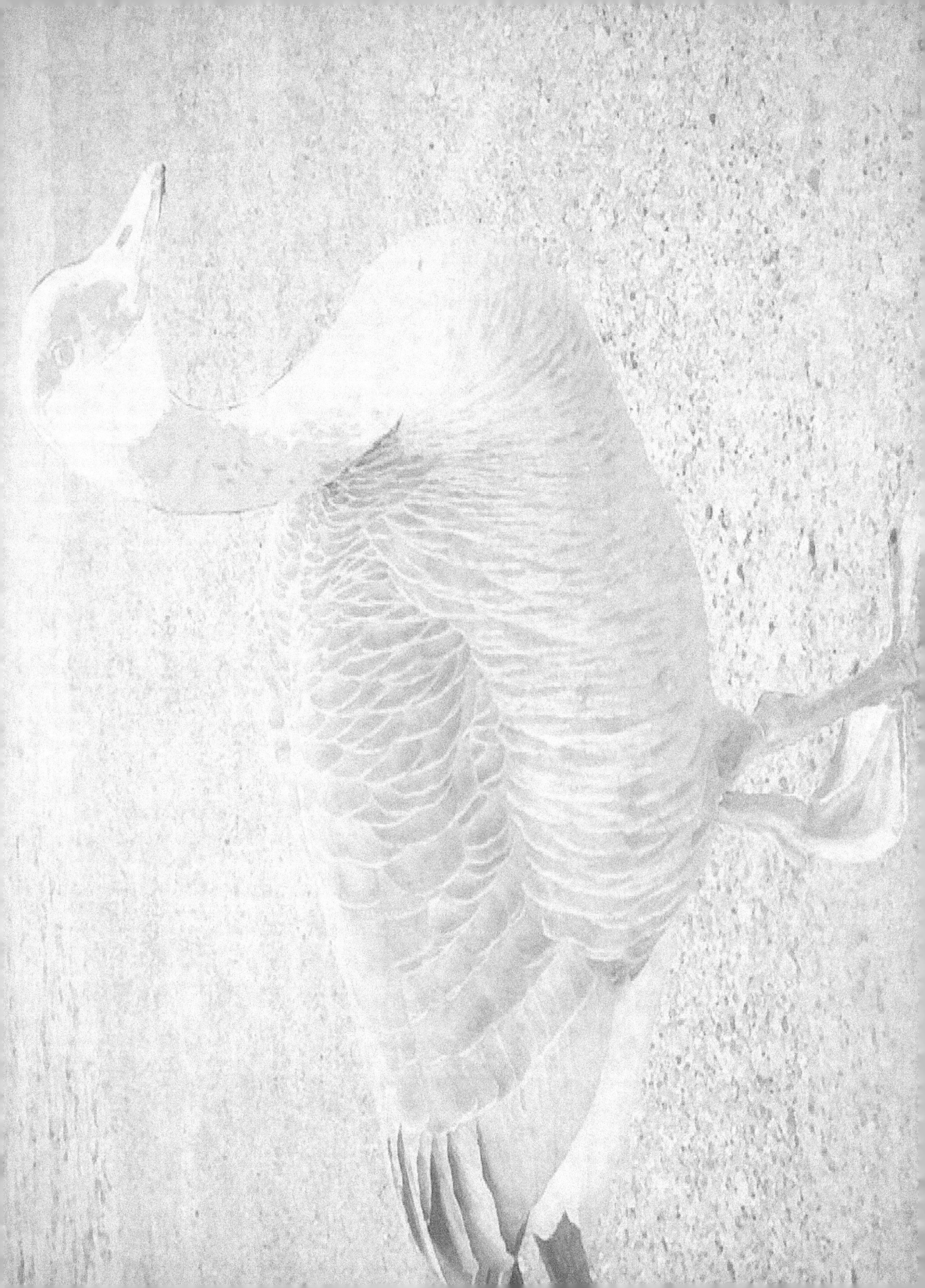

www.ingramcontent.com/pod-product-compliance
Lightning Source LLC
Chambersburg PA
CBHW081604220526
45468CB00010B/2762